Ad-y-tum: 1. a sacred place that the public is forbidden to enter; an inner shrine. 2. the most reserved of any place ; sanctum.

This book represents the images captured from Feelings experienced. Within these pages lies years of emotions that were once only seen from within. Pain and happiness. Fear and bravery. For me this was my only outlet. My garden. My adytum.

As I unfold what is true and undying Will most certainly unfold. It Will unveil itself in ways that allow me to grow.

May you find peace and comfort
within these lines.

E. Daniel Reeves

Instagram: E. Daniel Reeves Facebook: Garden by E. Daniel Reeves Twitter: EDRGarden

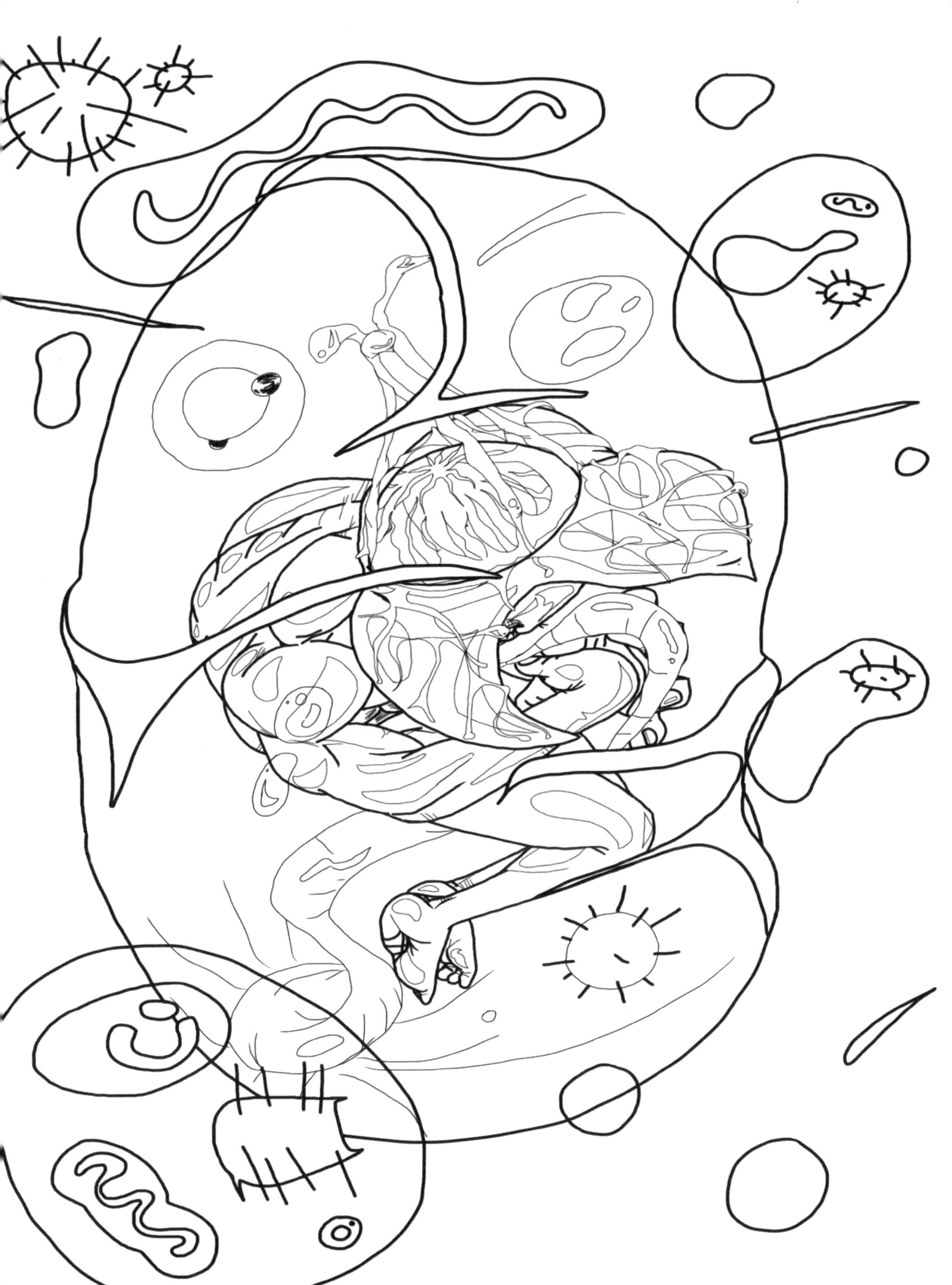

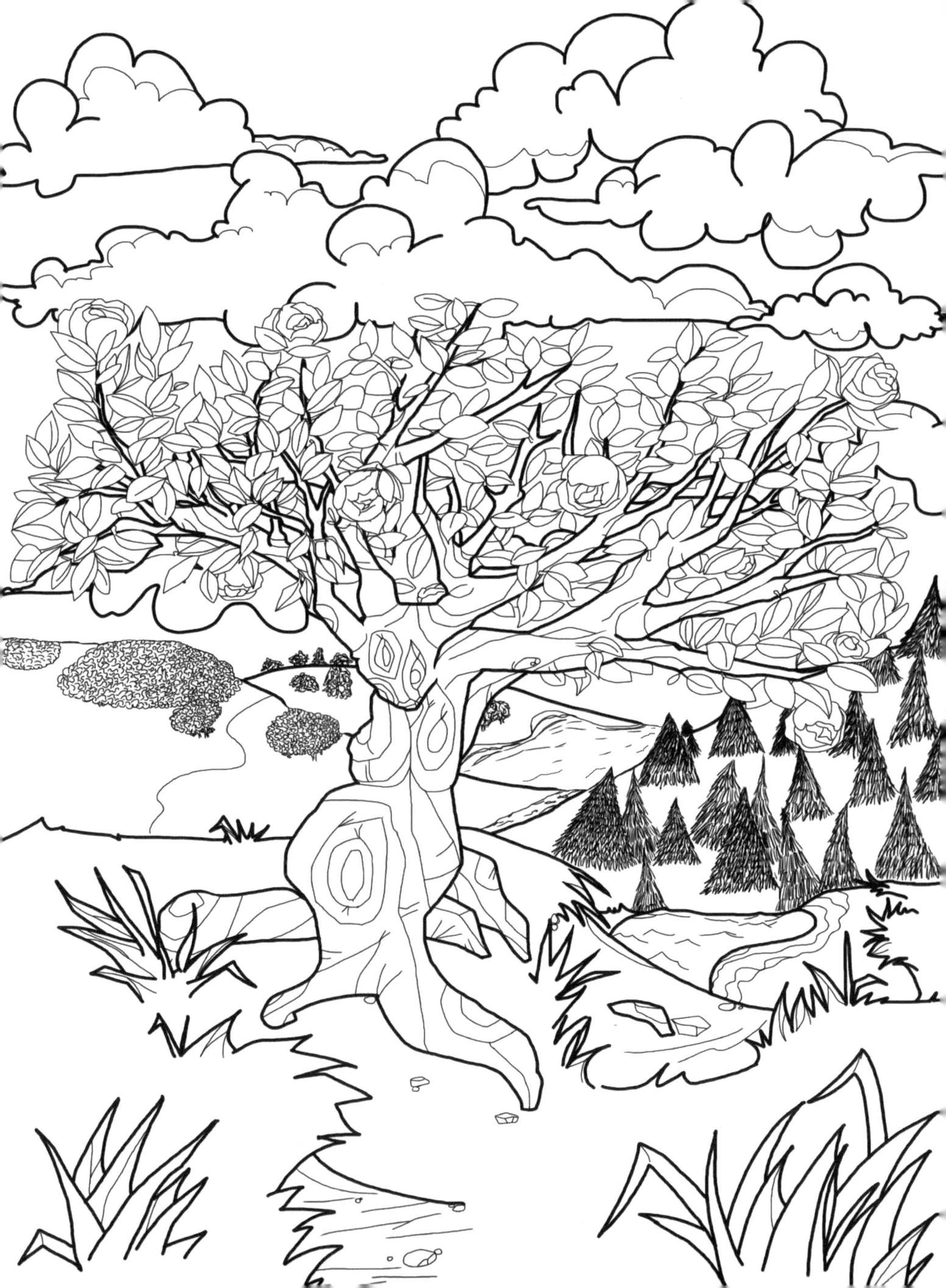

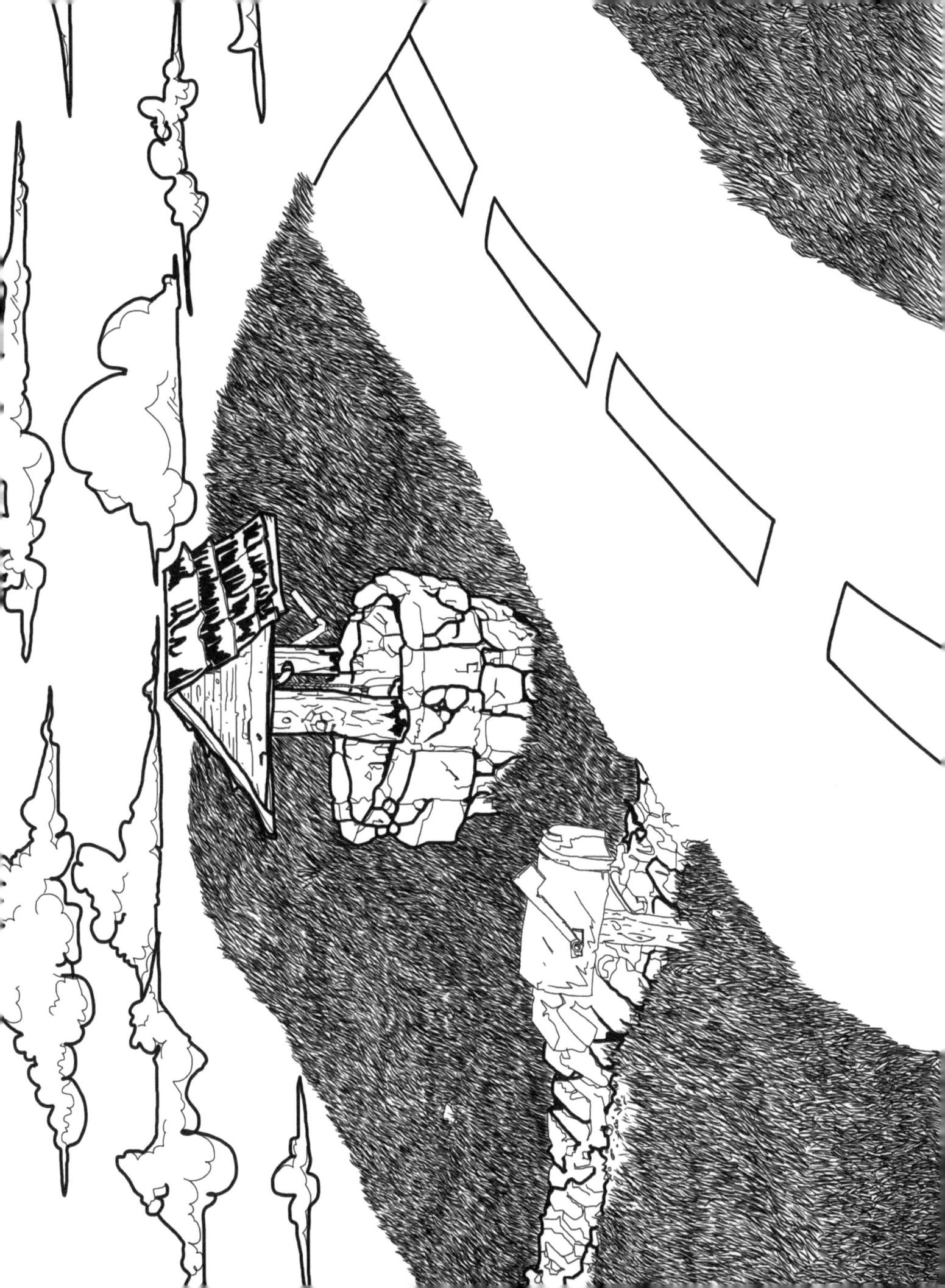

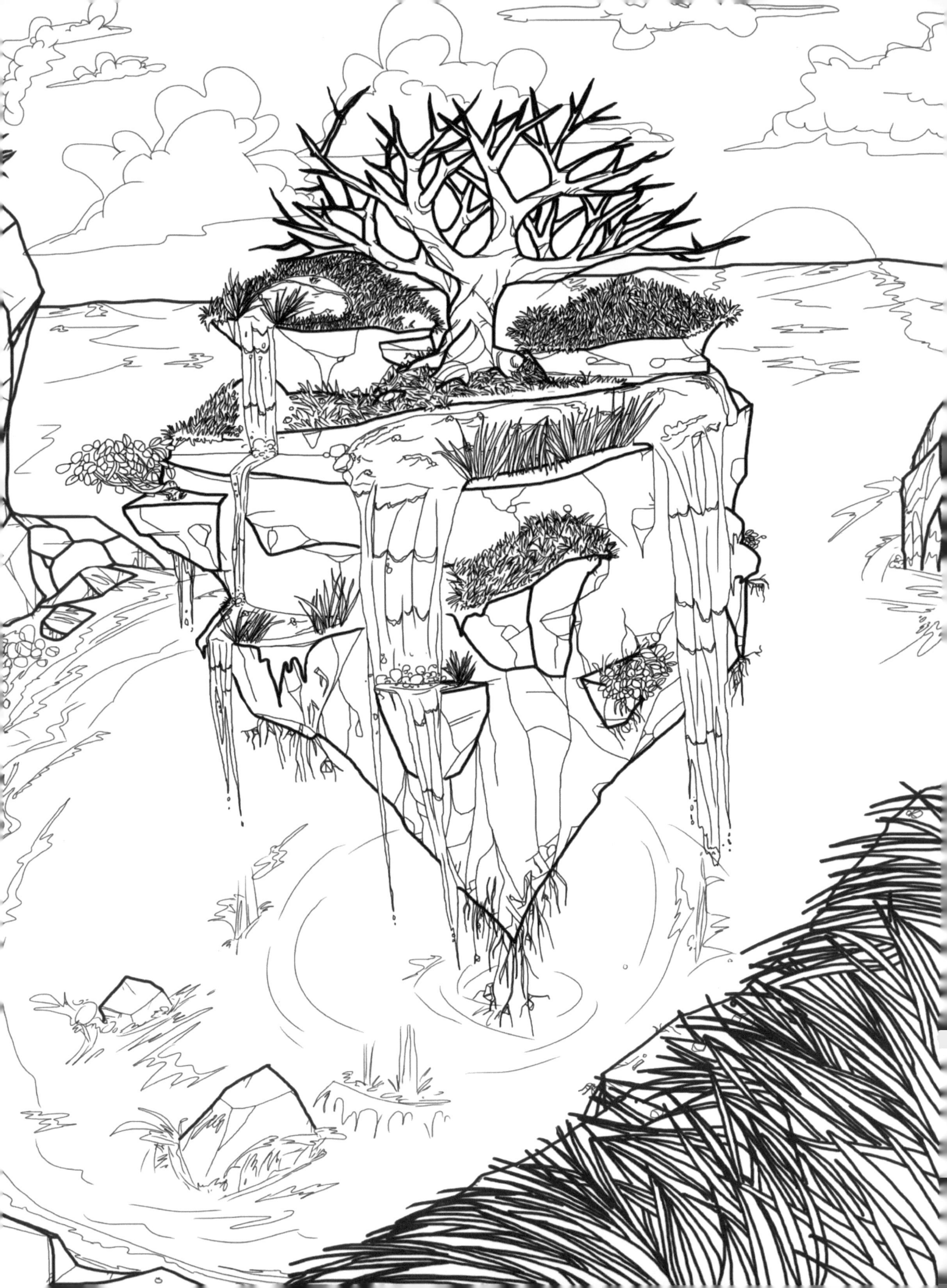

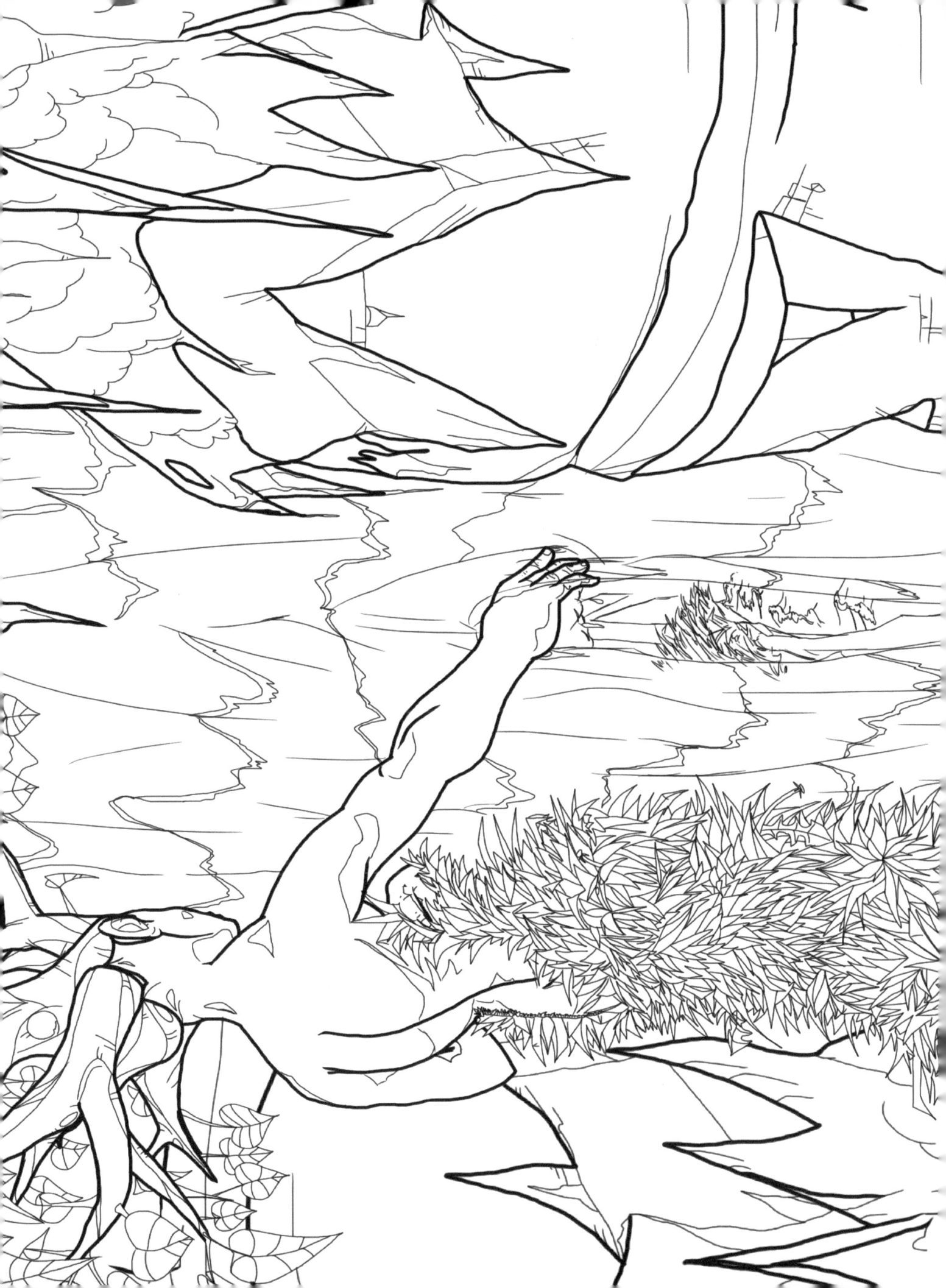

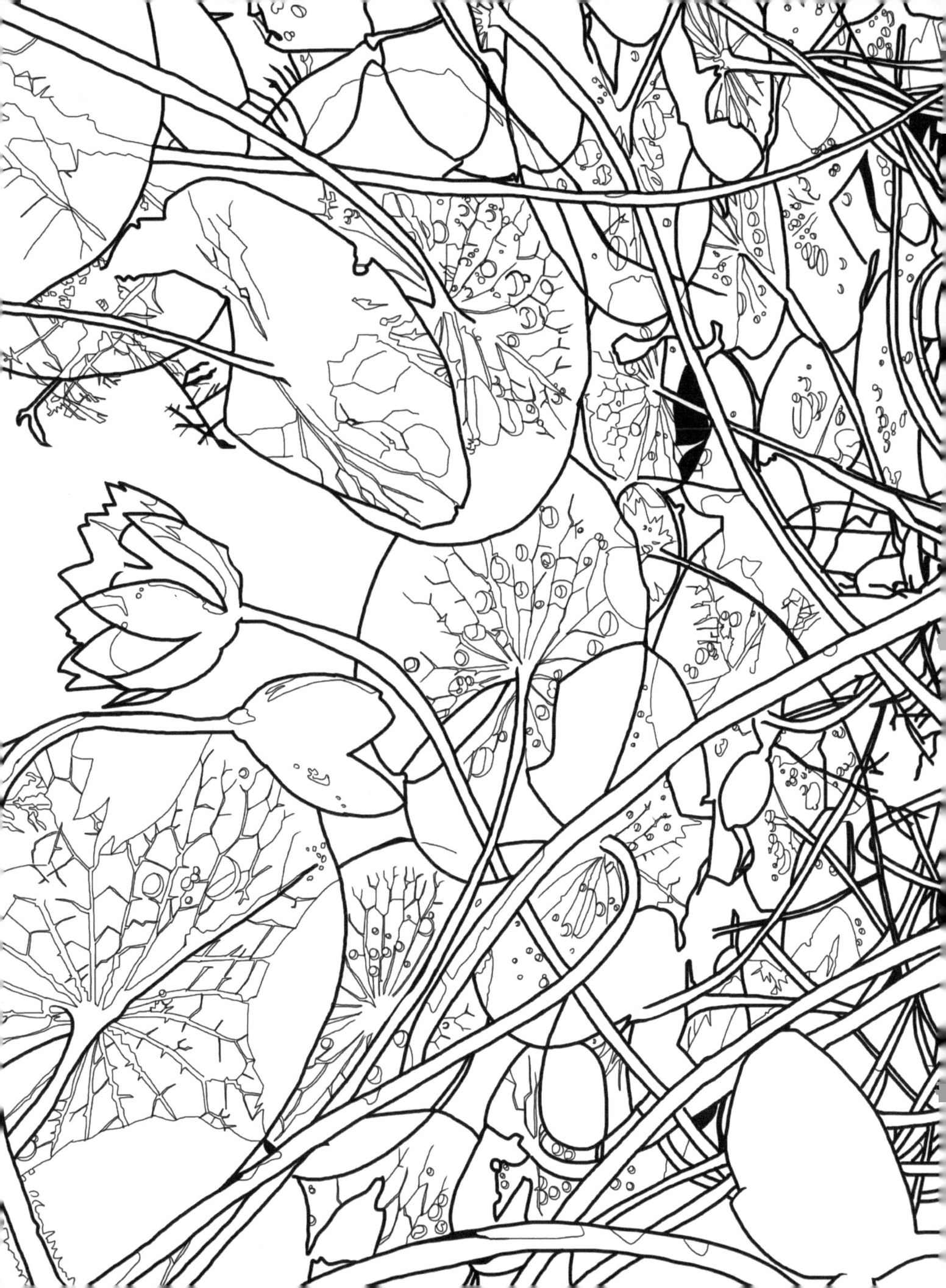

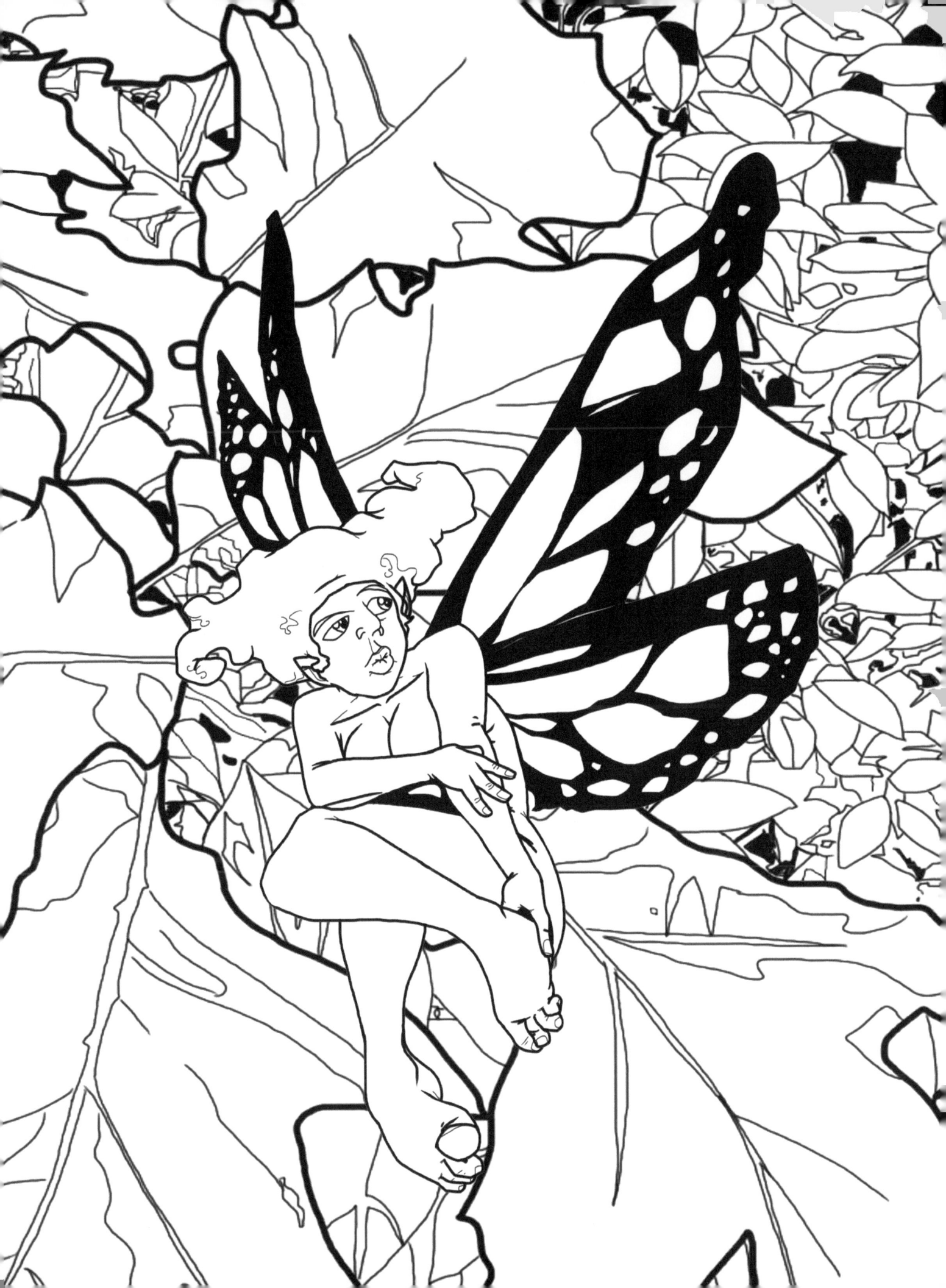

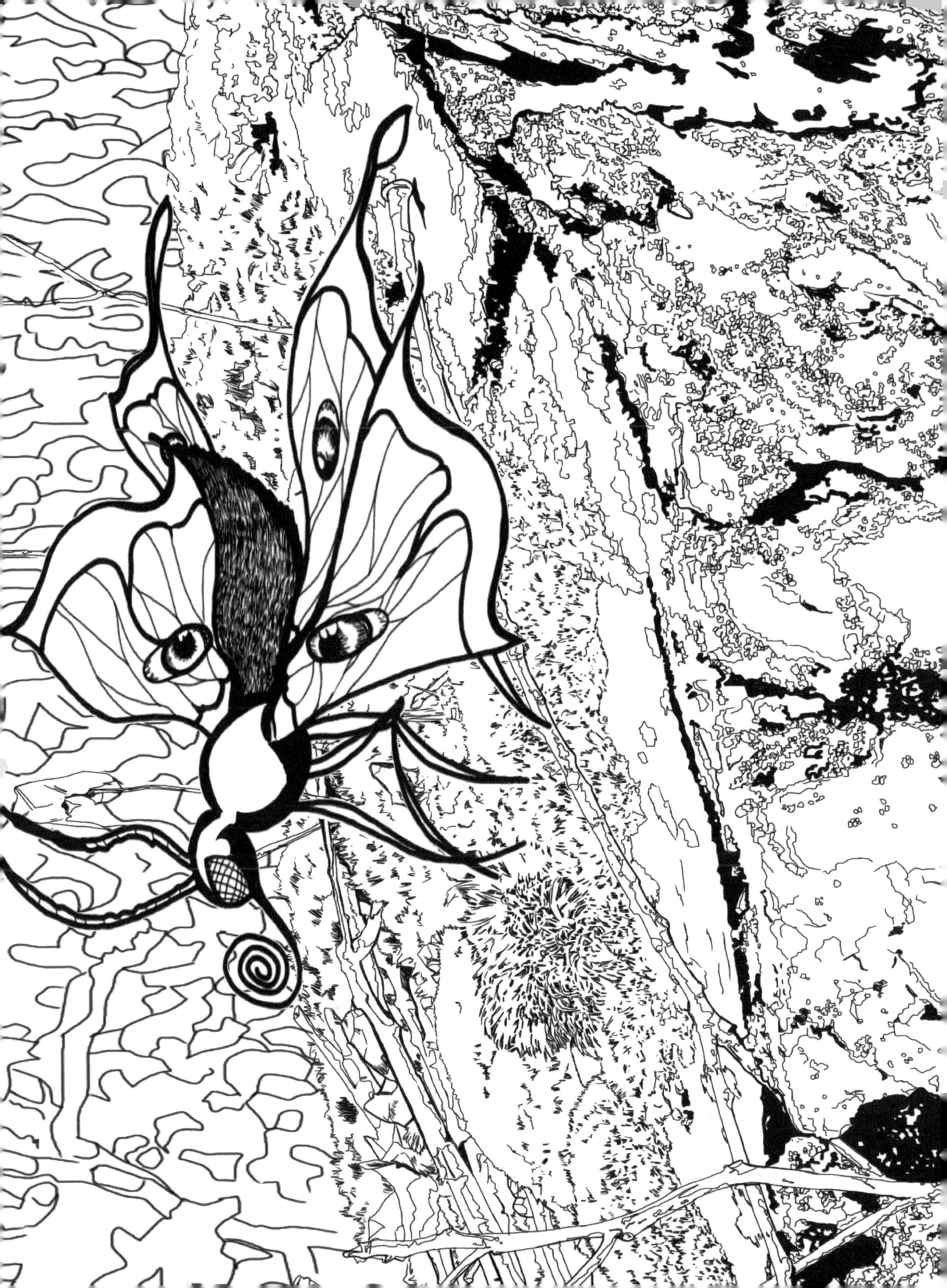

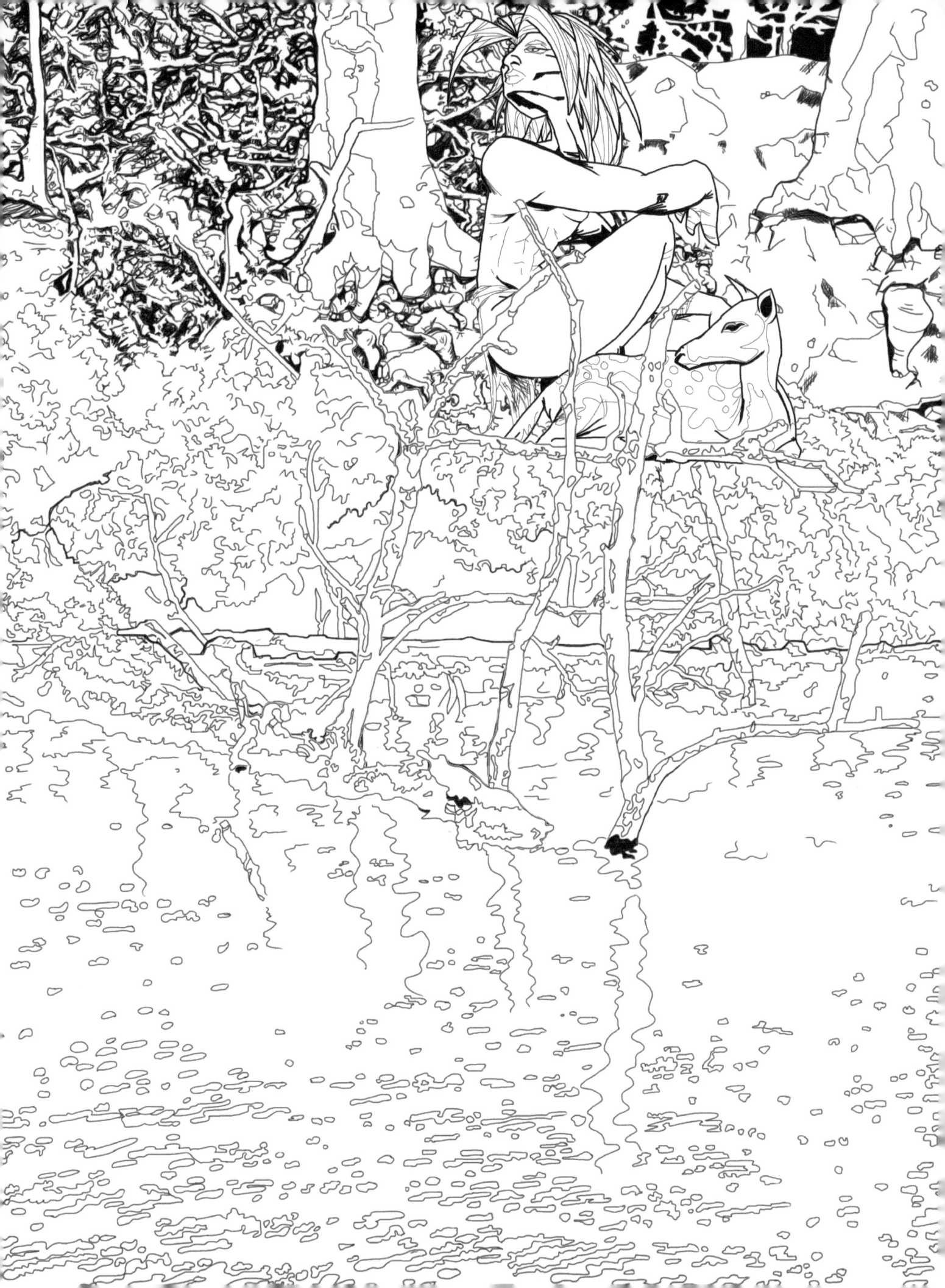

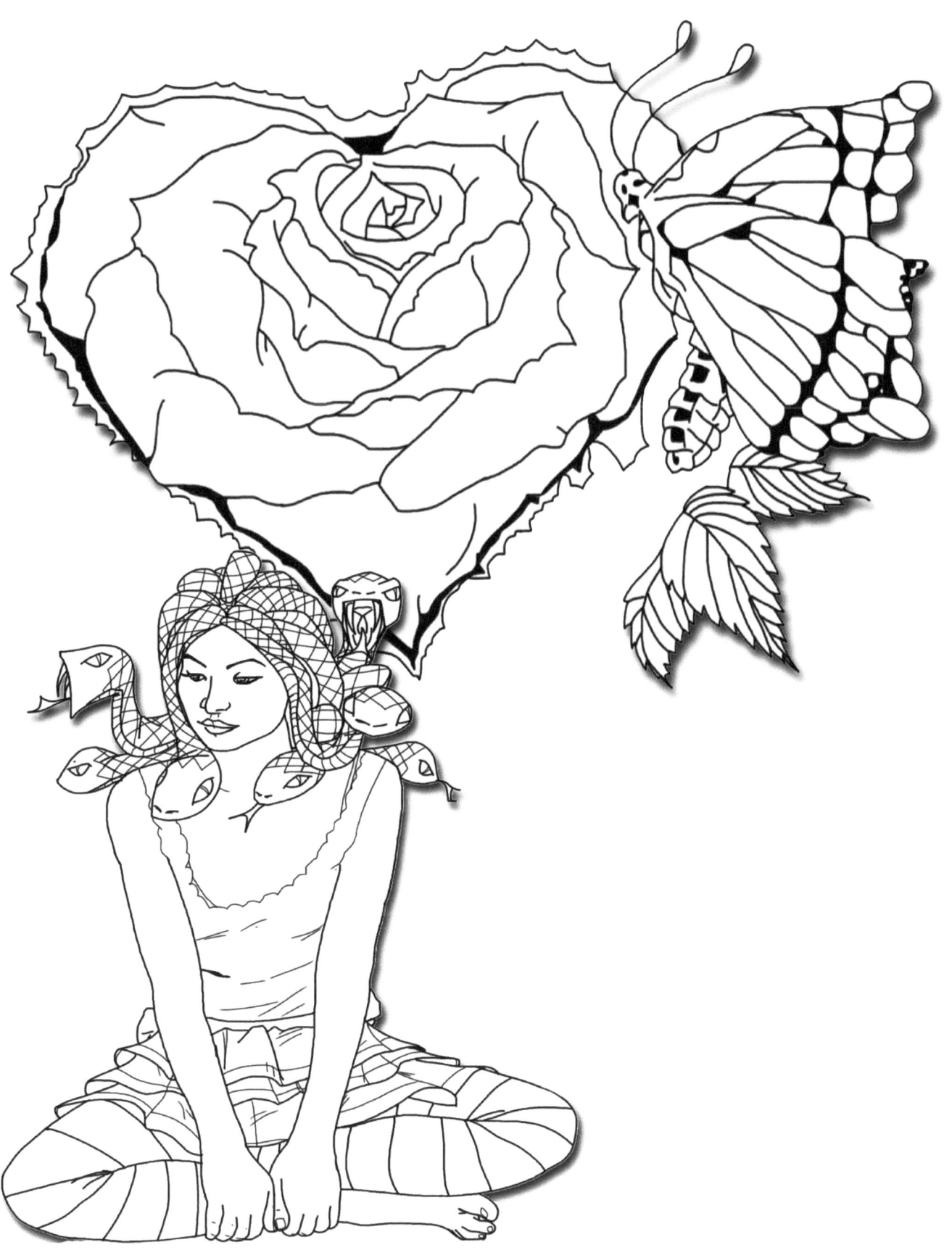

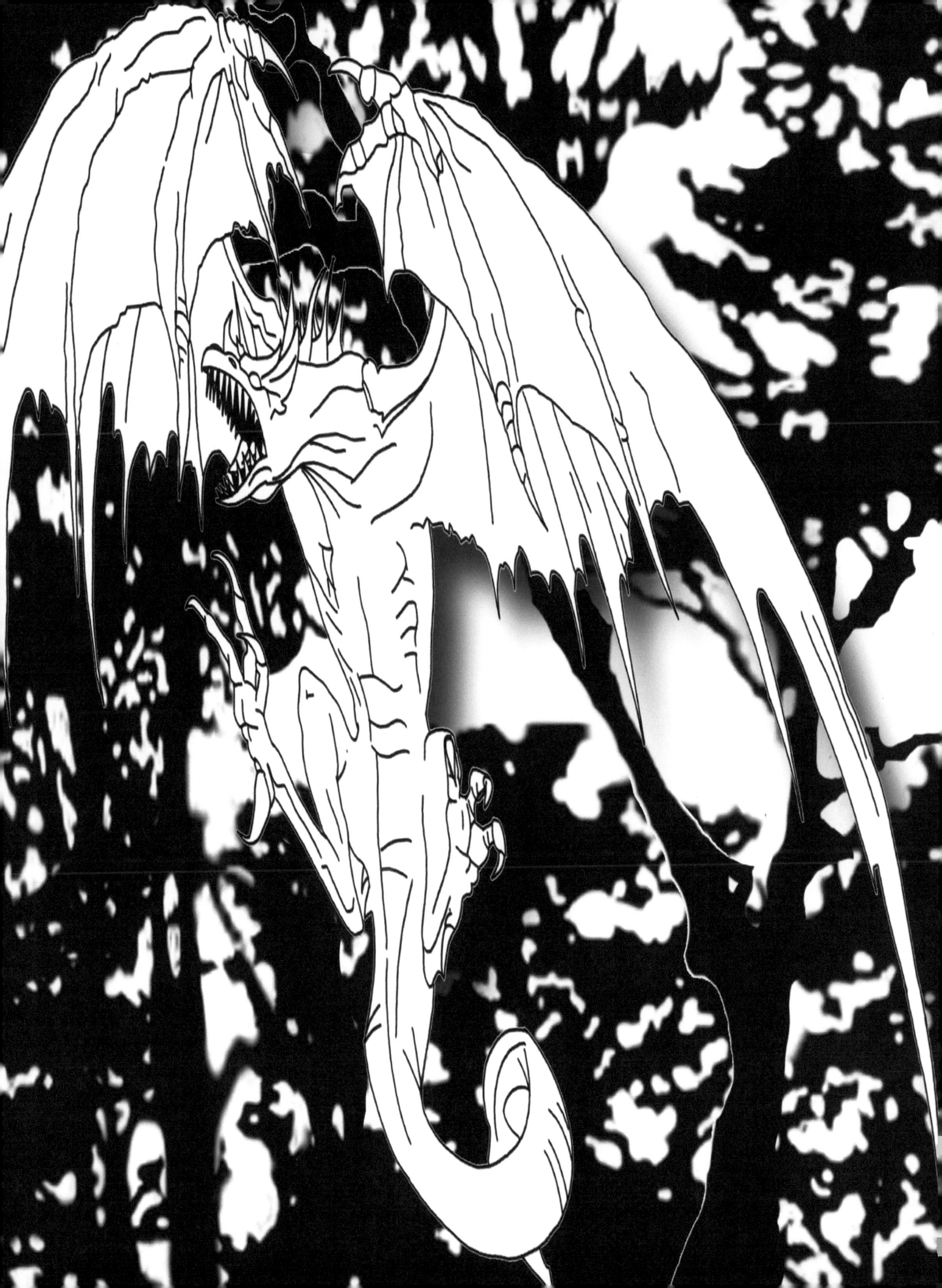

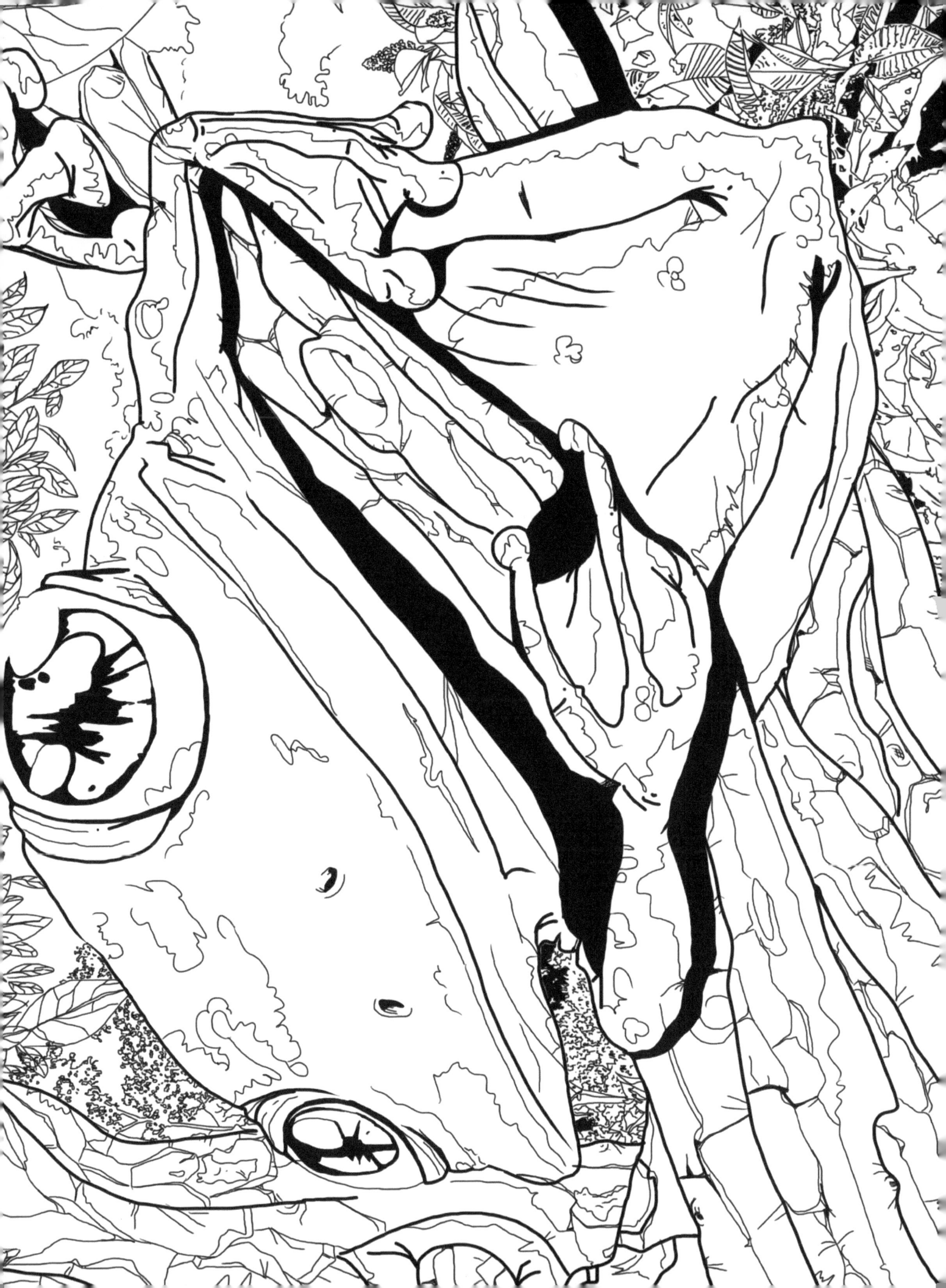

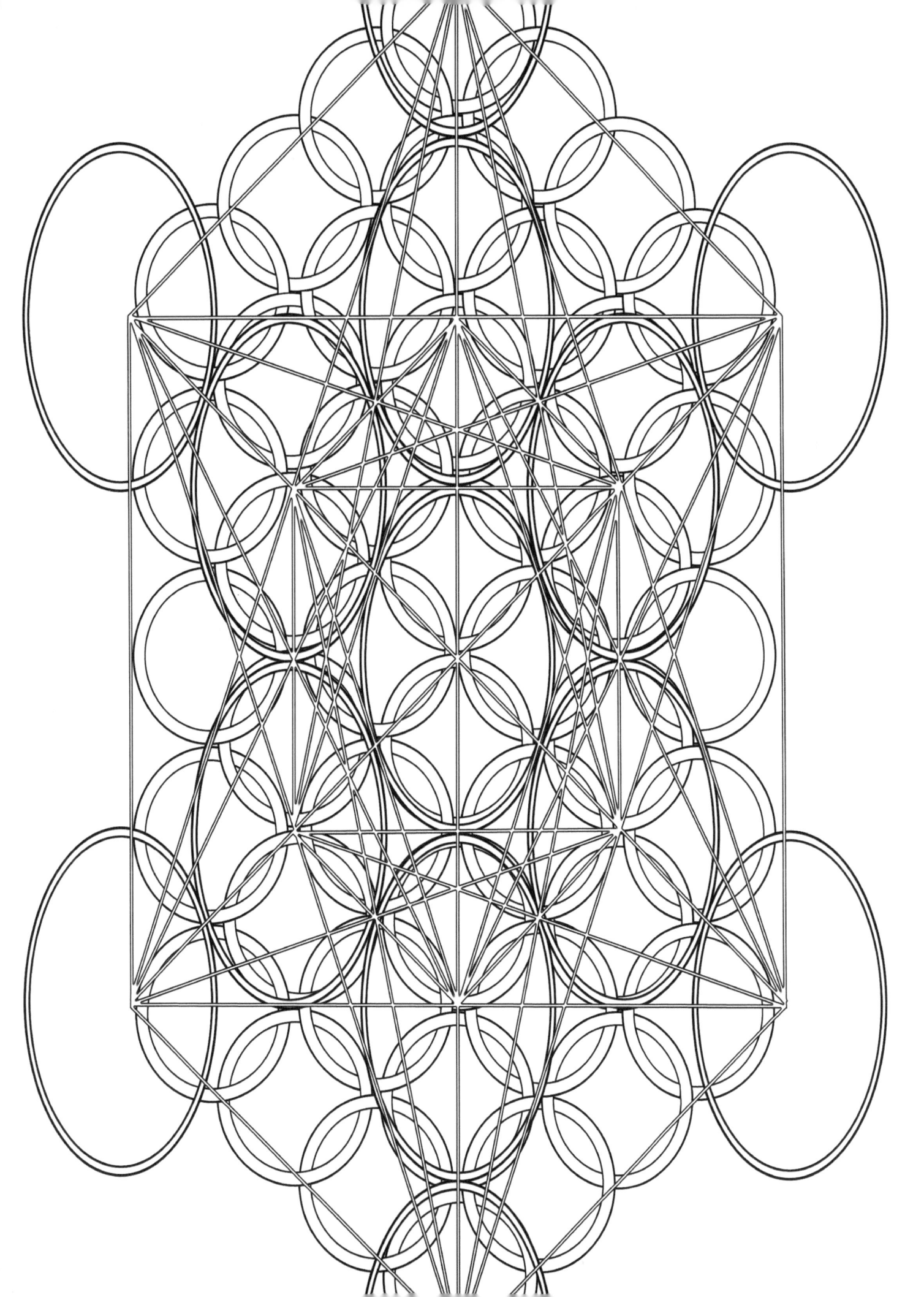

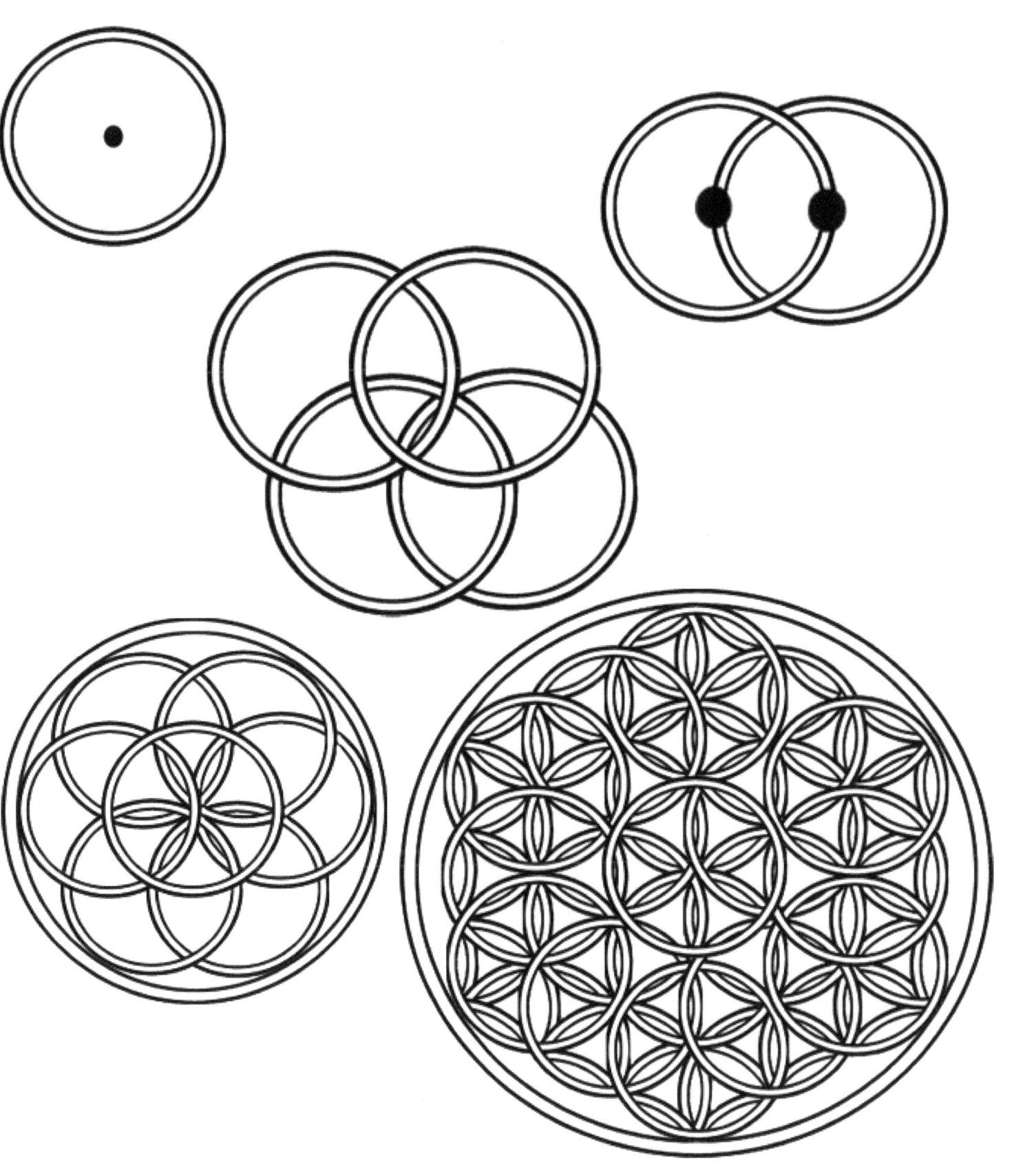

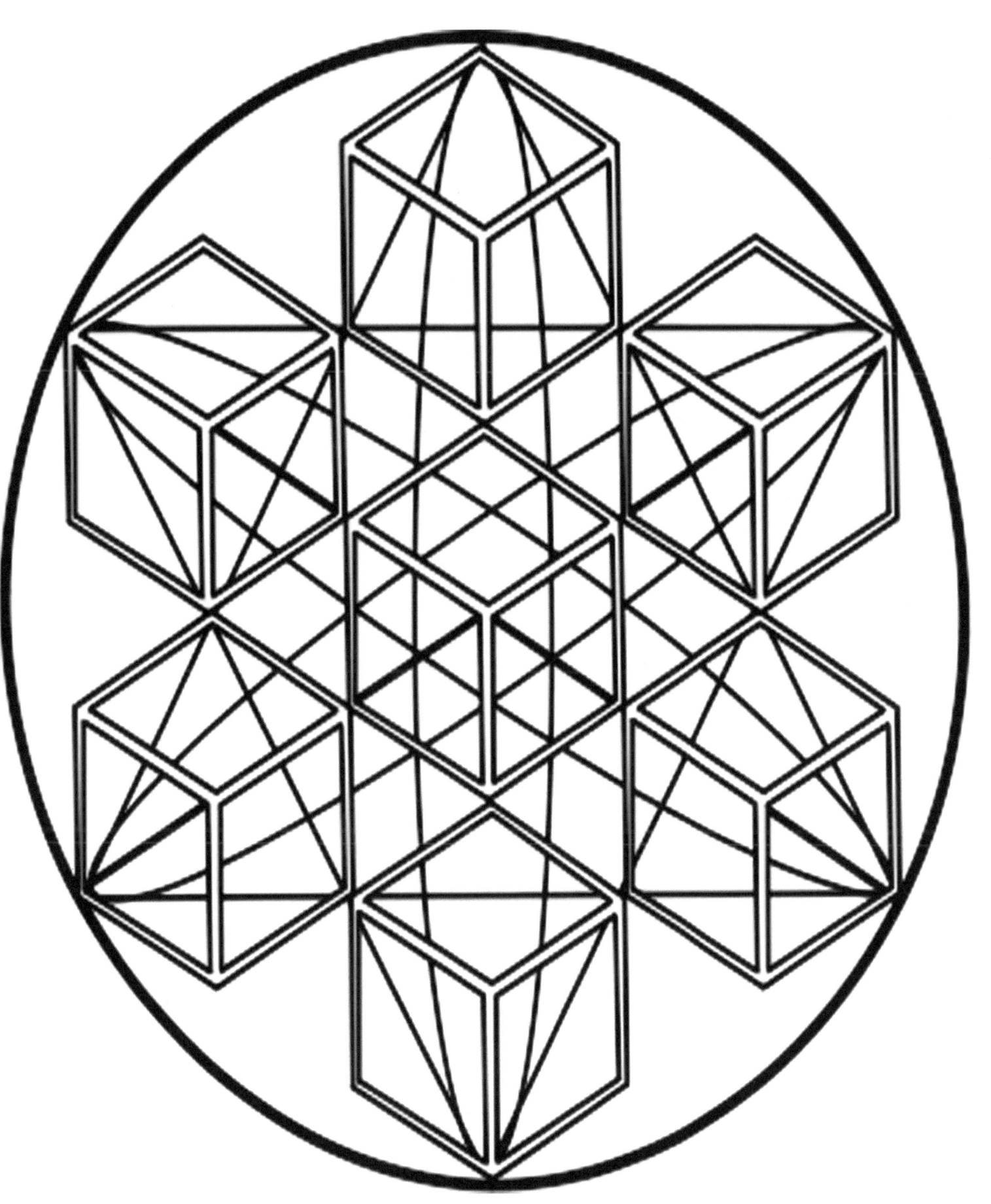

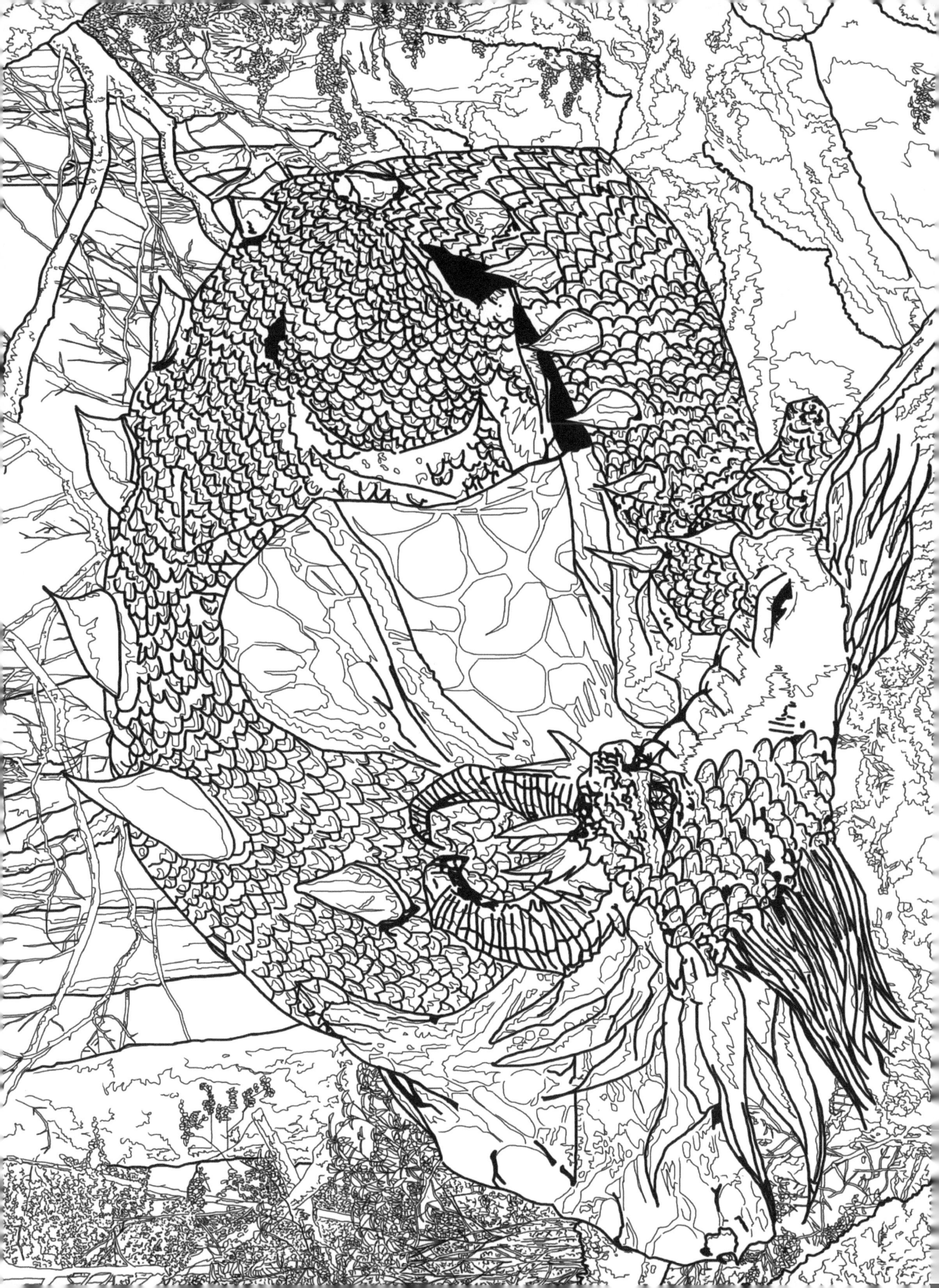

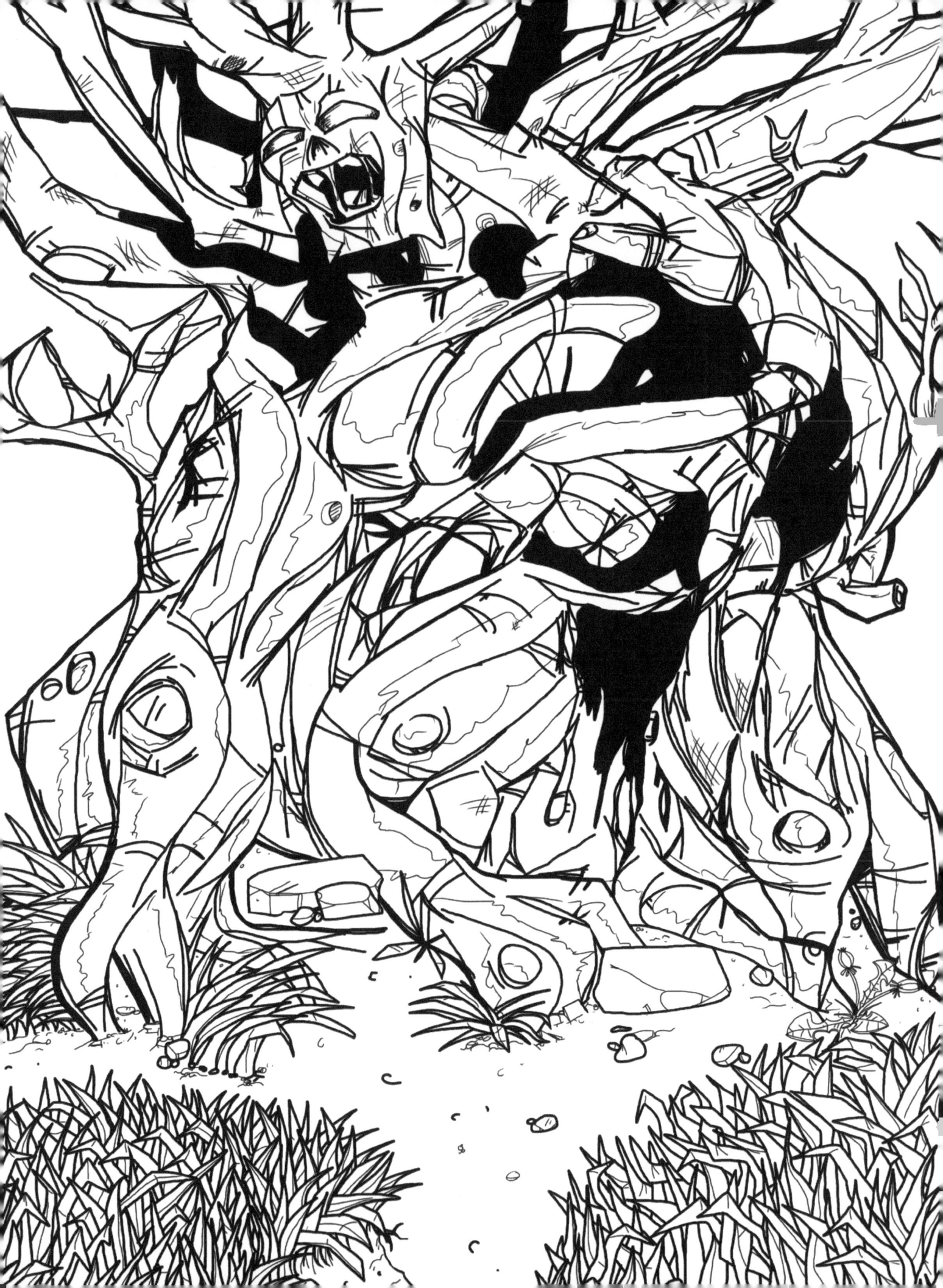

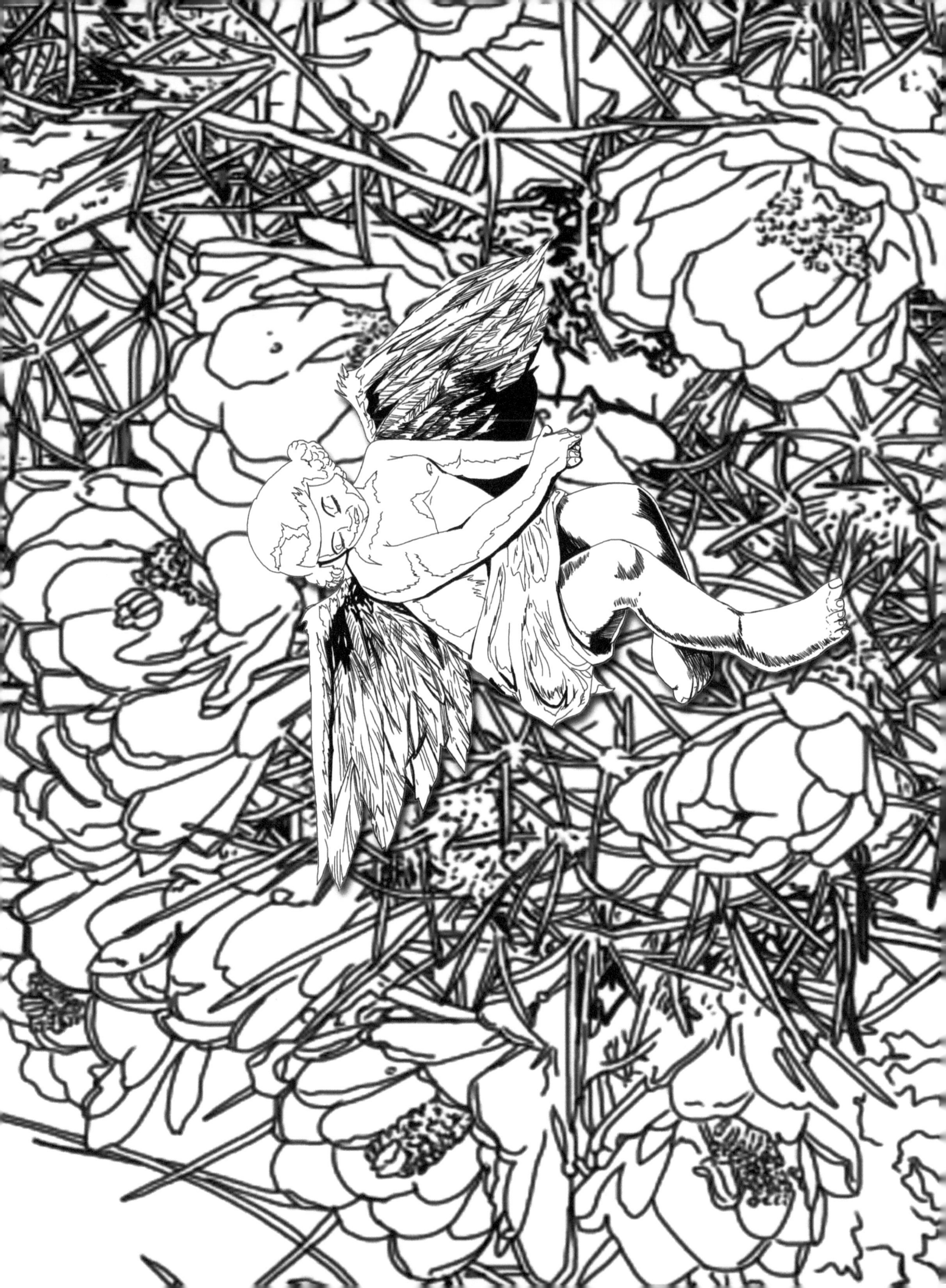

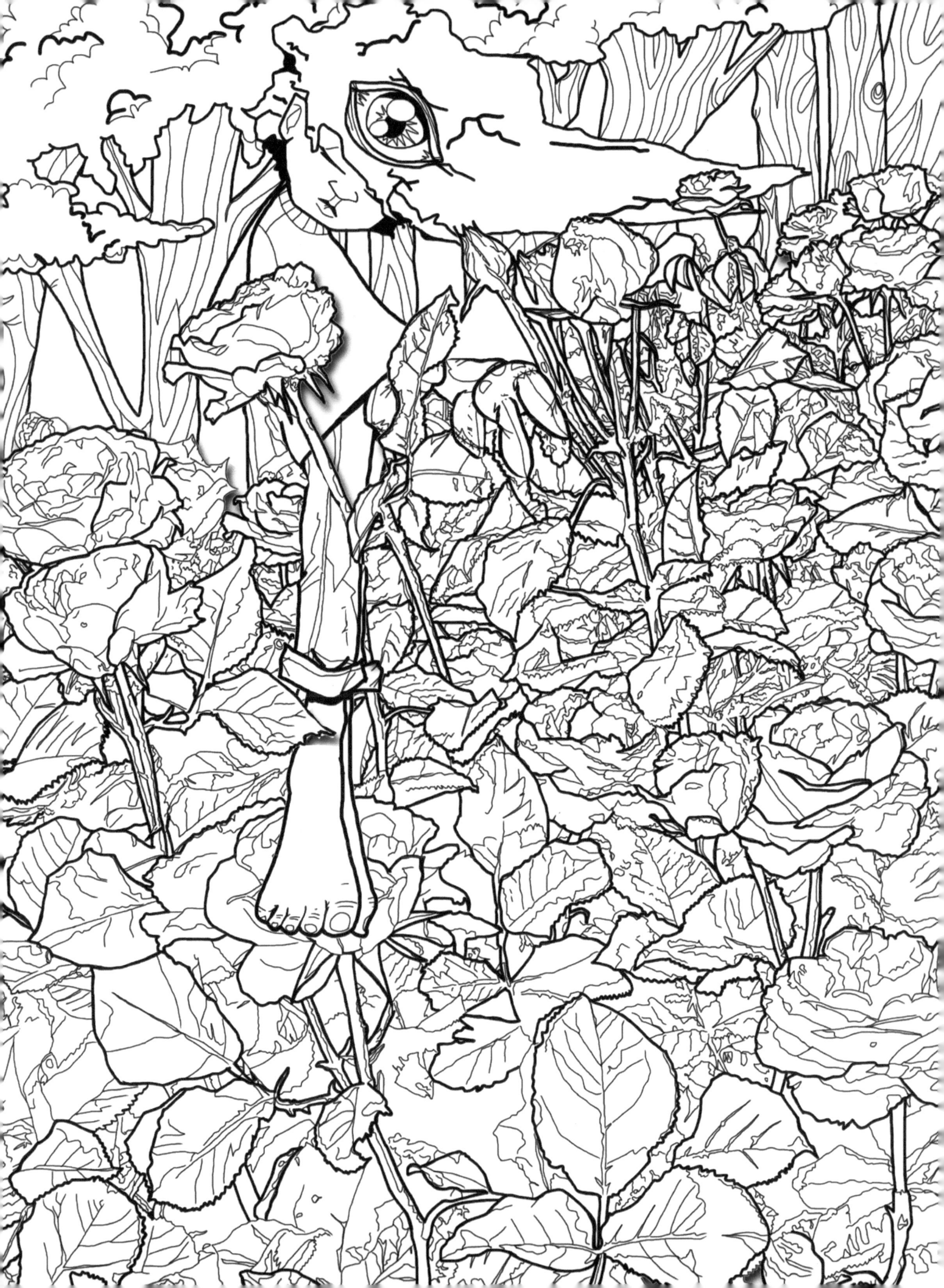

Colors

It is great practice to check out a color wheel when deciding on which hues to use in a particular design. Color wheels help you to see which colors work well together. This color wheel shows the 3 types of colors: primary, secondary, and tertiary.

Primary Colors
These consist of the colors red, blue, and yellow. With these base colors you can create all other colors.

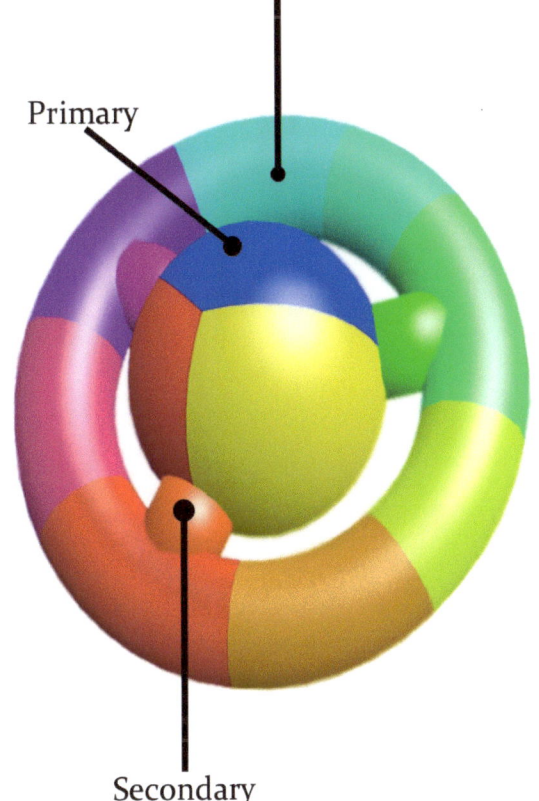

Secondary Colors
These are the colors made when mixing 2 primary colors. They are orange, purple, and green.

Tertiary Colors
These are produced by an equal mixture of a primary color with a secondary color adjacent to it on the color wheel.

Tints are colors with a certain level of white while shades are colors with black added.

Warm Colors
These are the vibrant colors that exist on one side of the color wheel. These colors are reds, oranges, and yellows.

Cool Colors
These are the relaxing and soothing hues opposite the warm colors on the color wheel. They are greens, blues, and purples.

Complementary colors are the colors directly across from one another like red and green. These colors provide a strong contrast. Analogous colors, which are those colors sitting side by side on the color wheel, give you more of a balanced mix.

www.ingramcontent.com/pod-product-compliance
Lightning Source LLC
Chambersburg PA
CBHW041315180526
45172CB00004B/1111